SWEAR WORD
COLORING BOOK FOR ADULTS

This Book Belongs To:

Disclaimer

All rights reserved. No part of this publication or the information in it may be quoted from or reproduced in any from by means such a printing, scanning, photocopying or otherwise without prior written permission of the copyright holder.

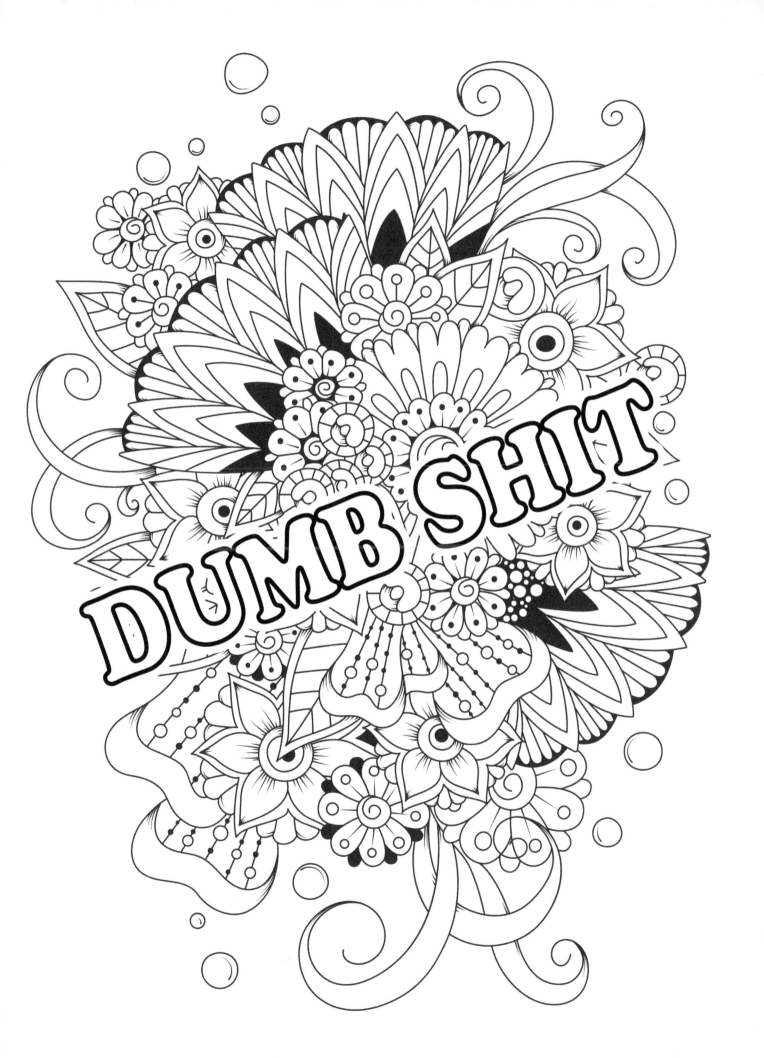

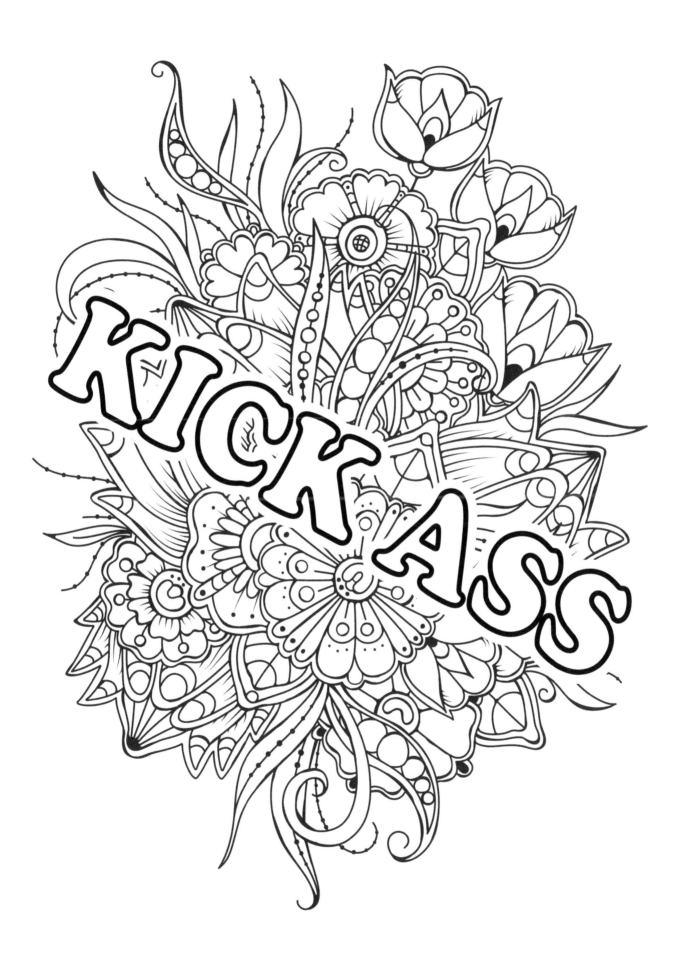

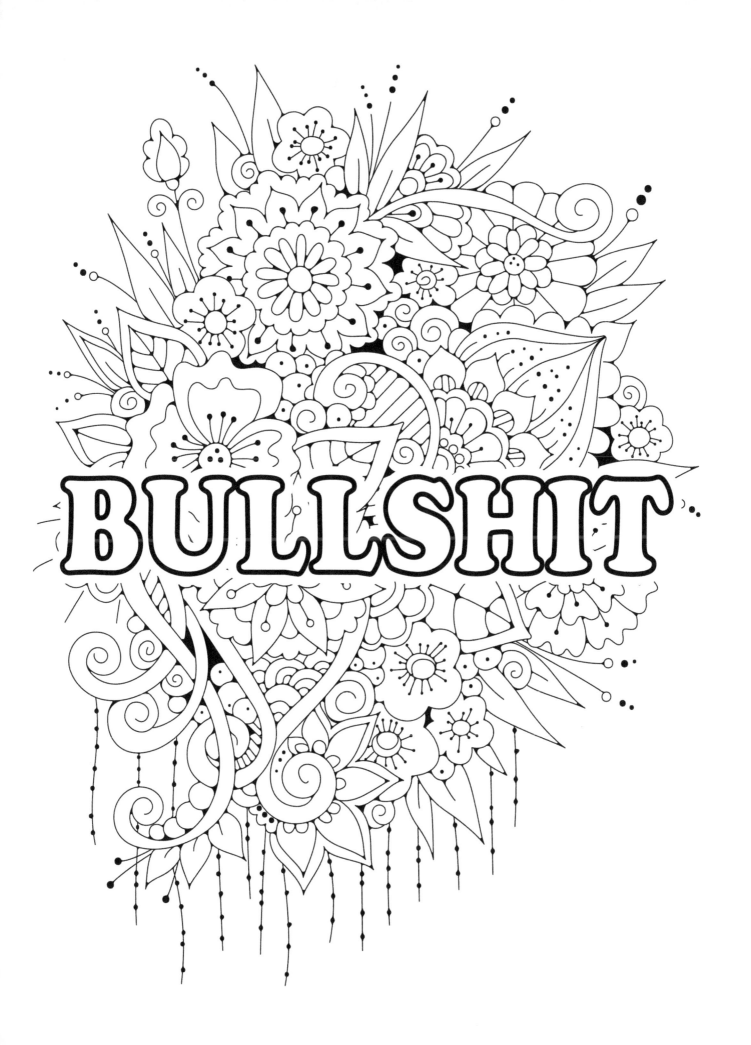

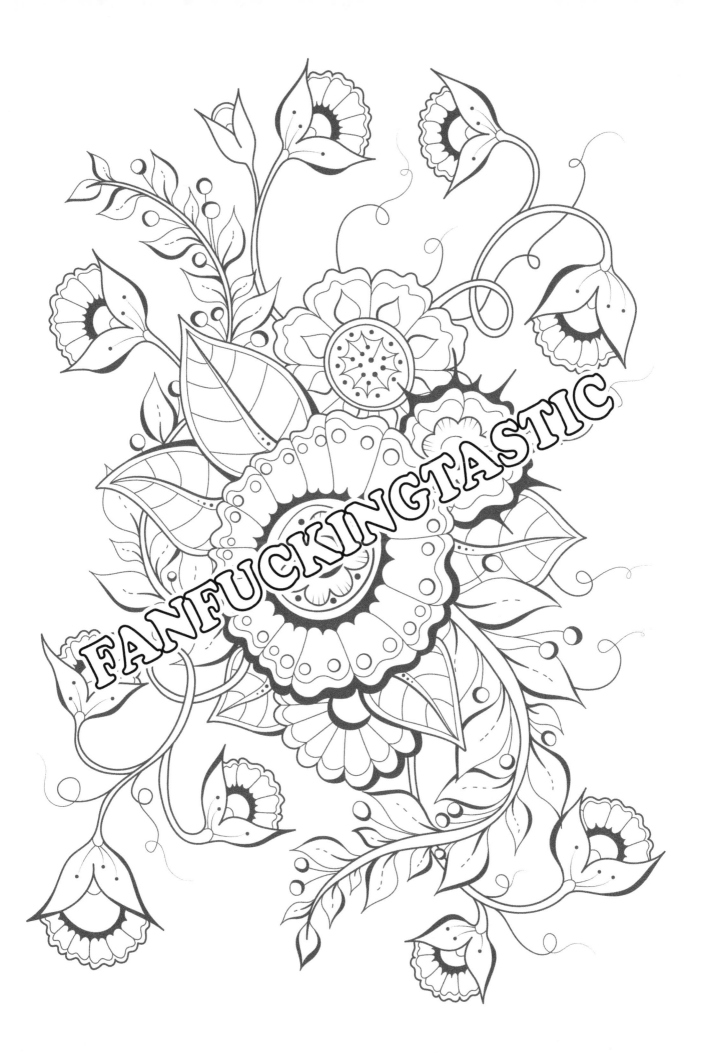

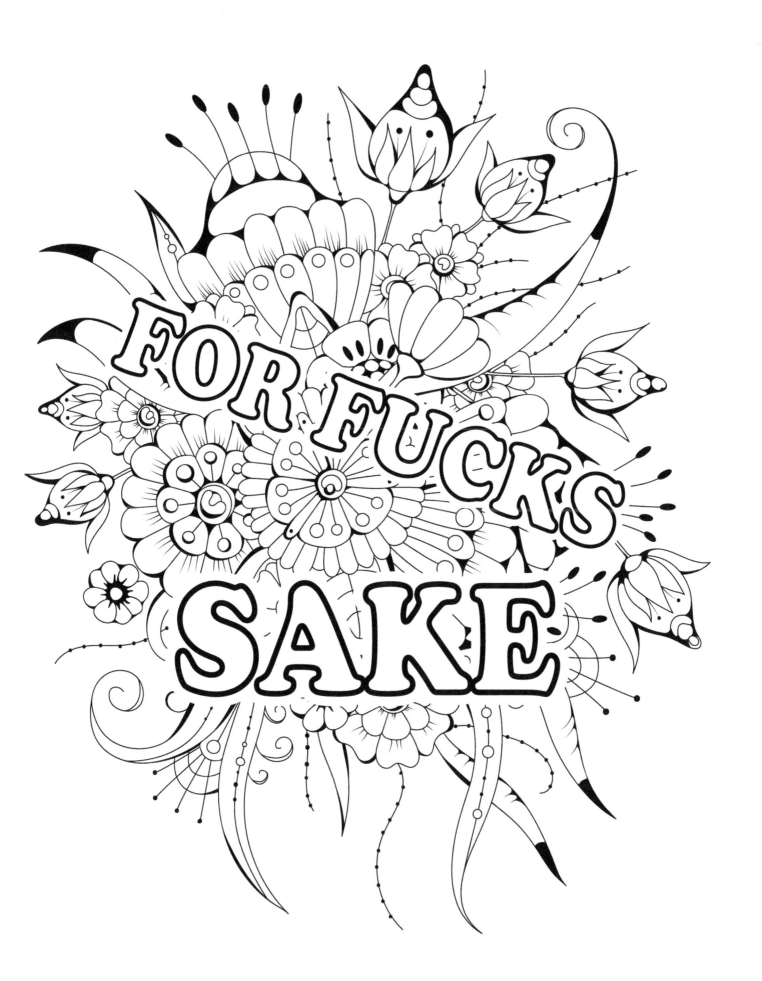

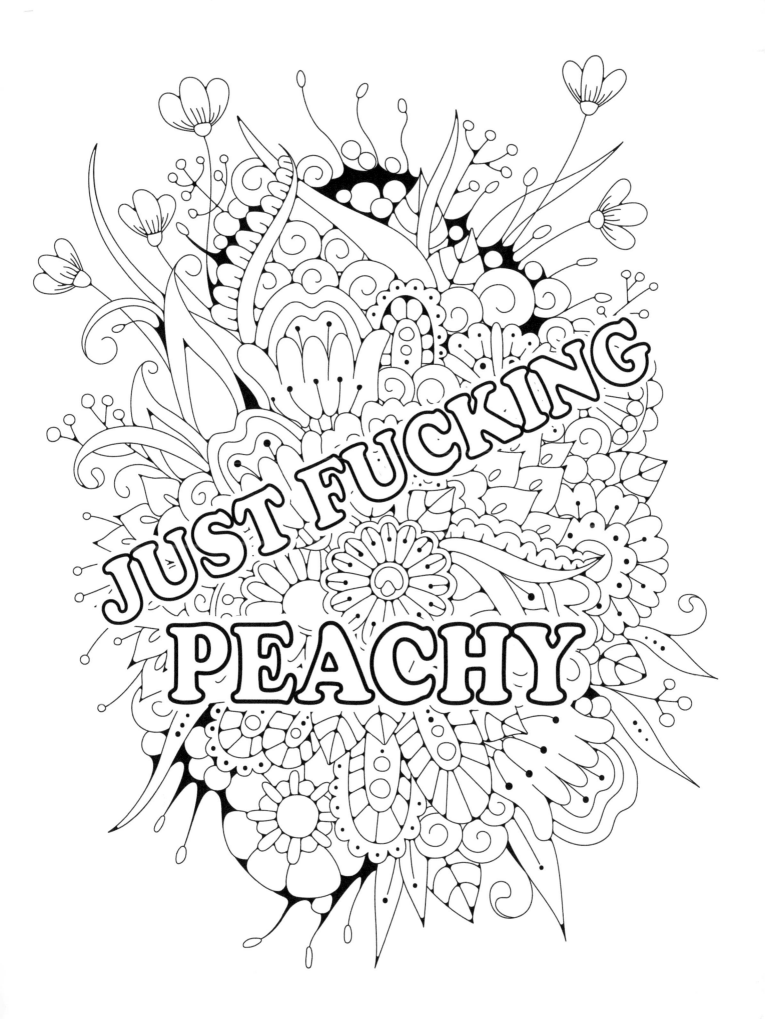

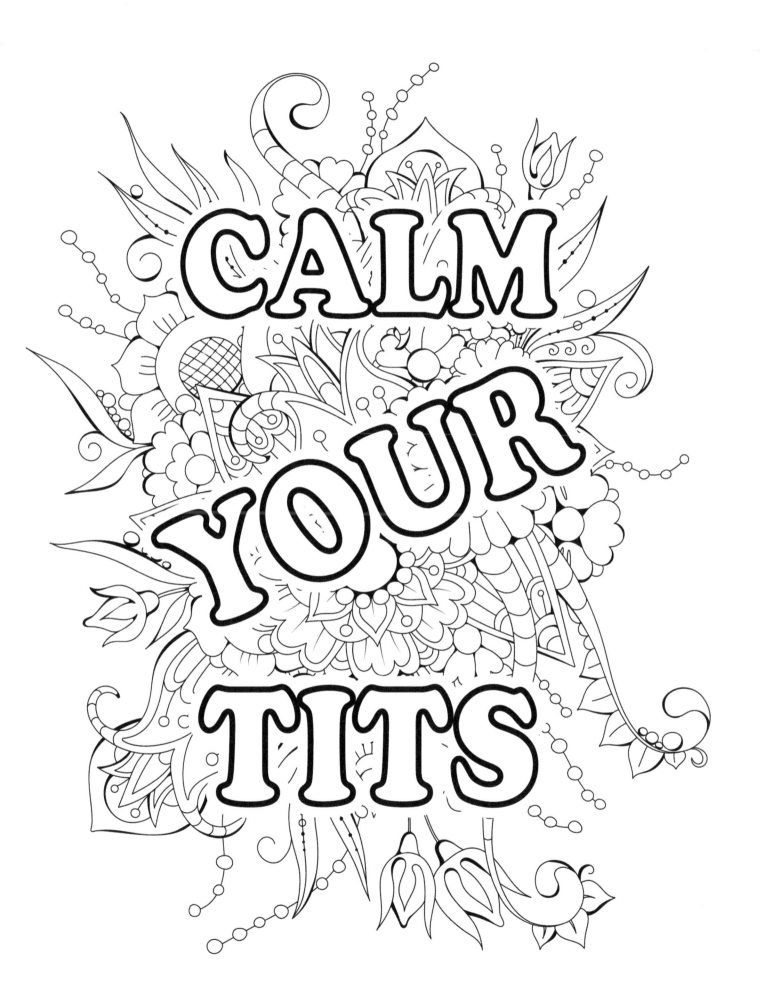

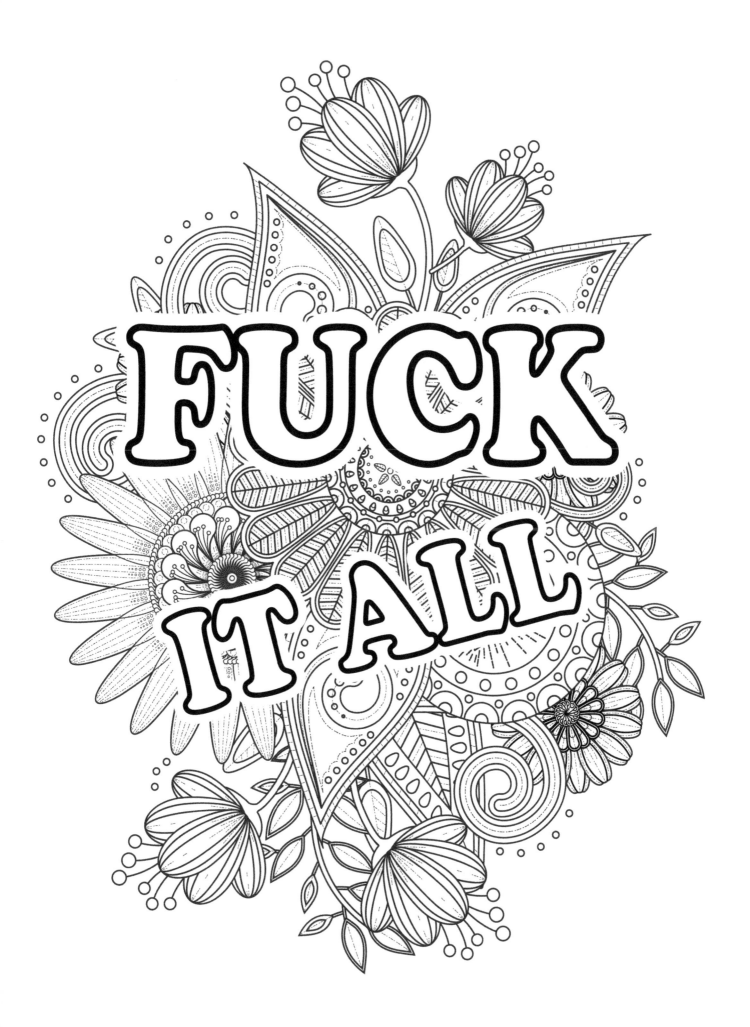

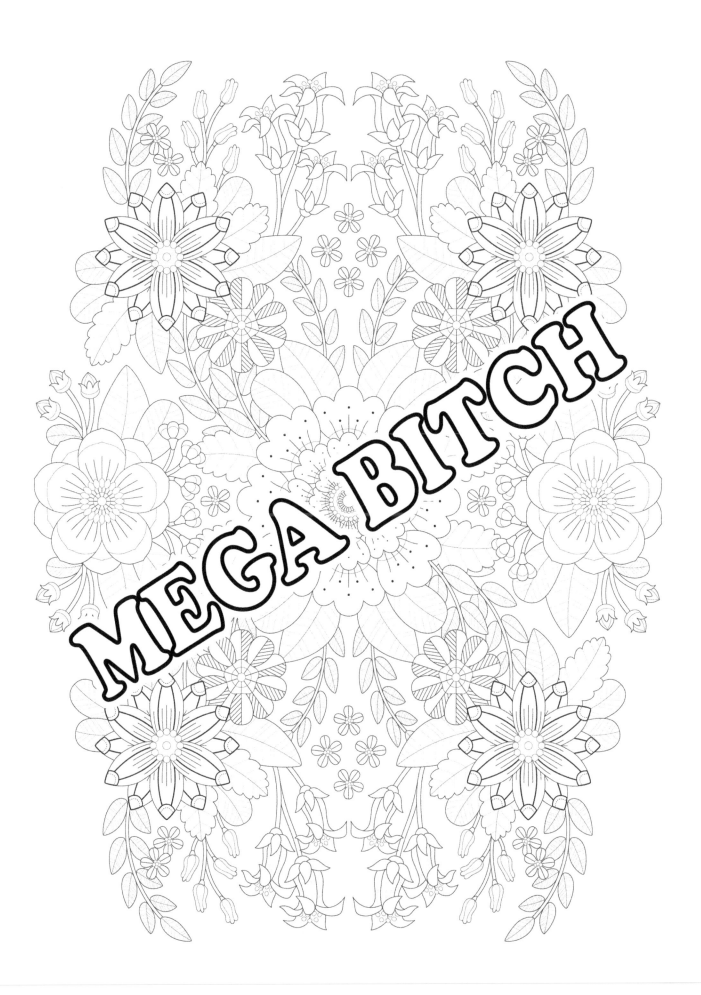

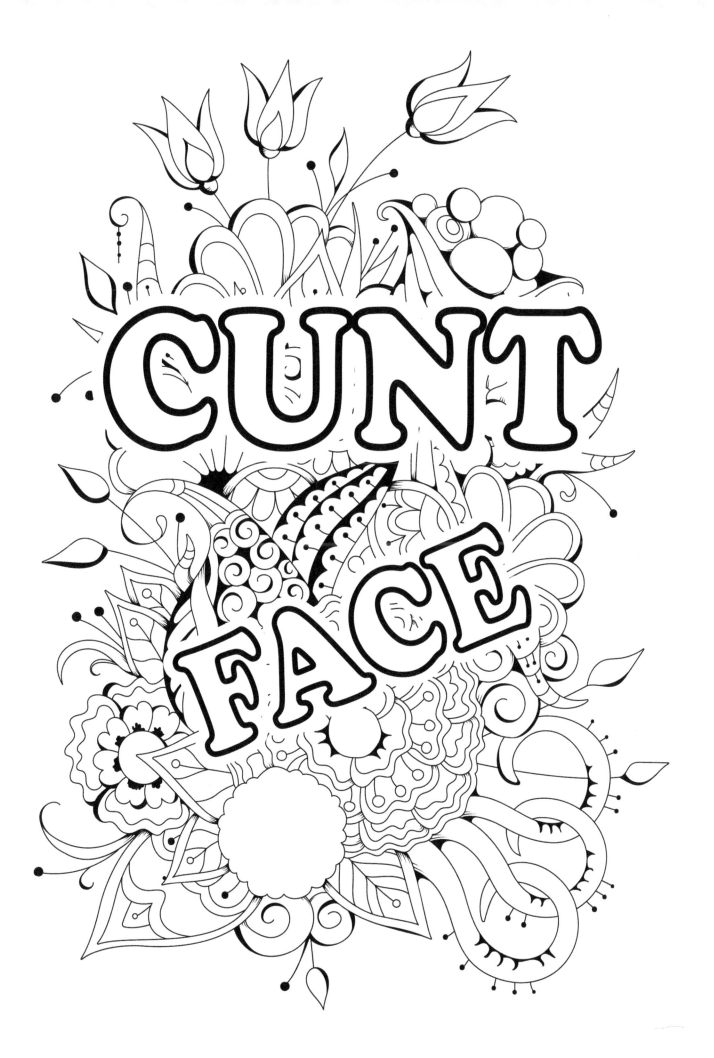

BITCH ASS
GARDEN

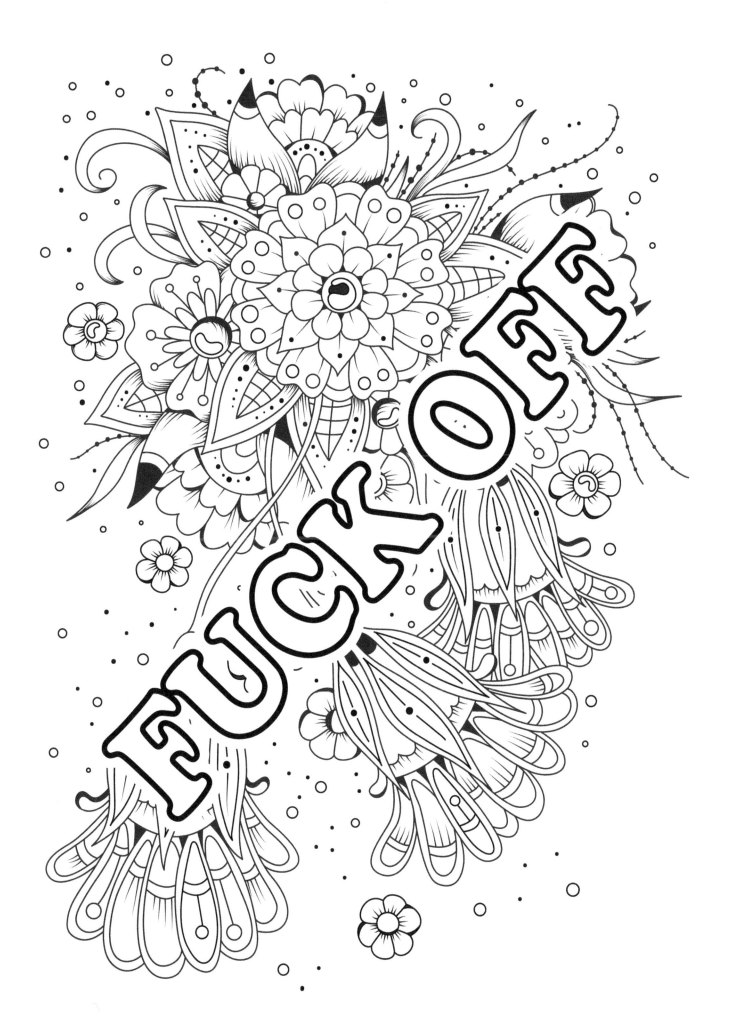

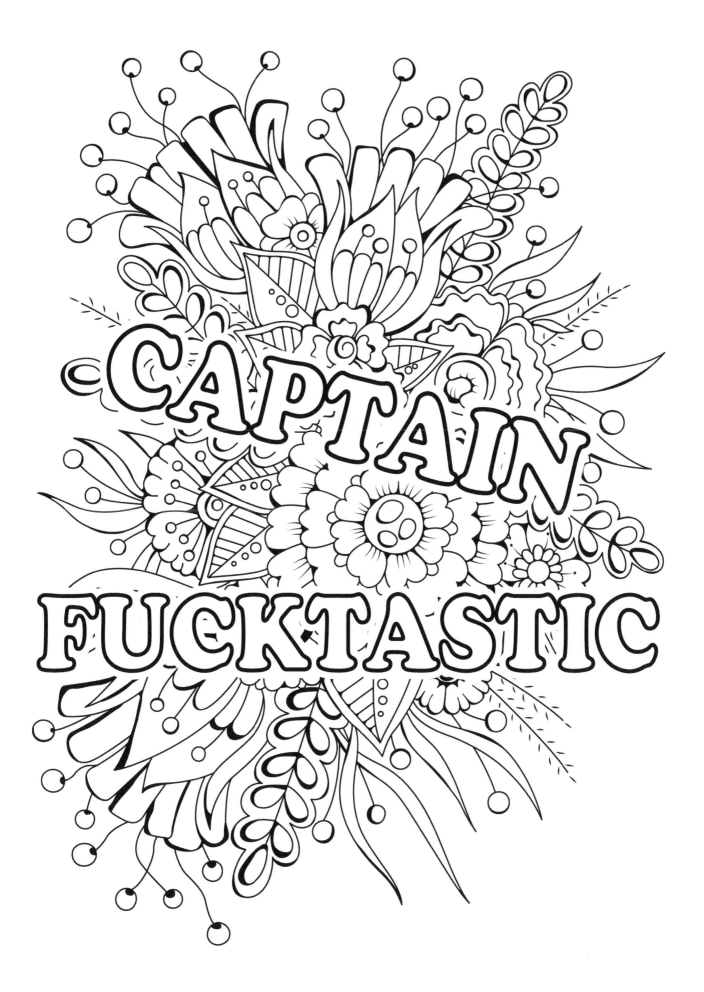

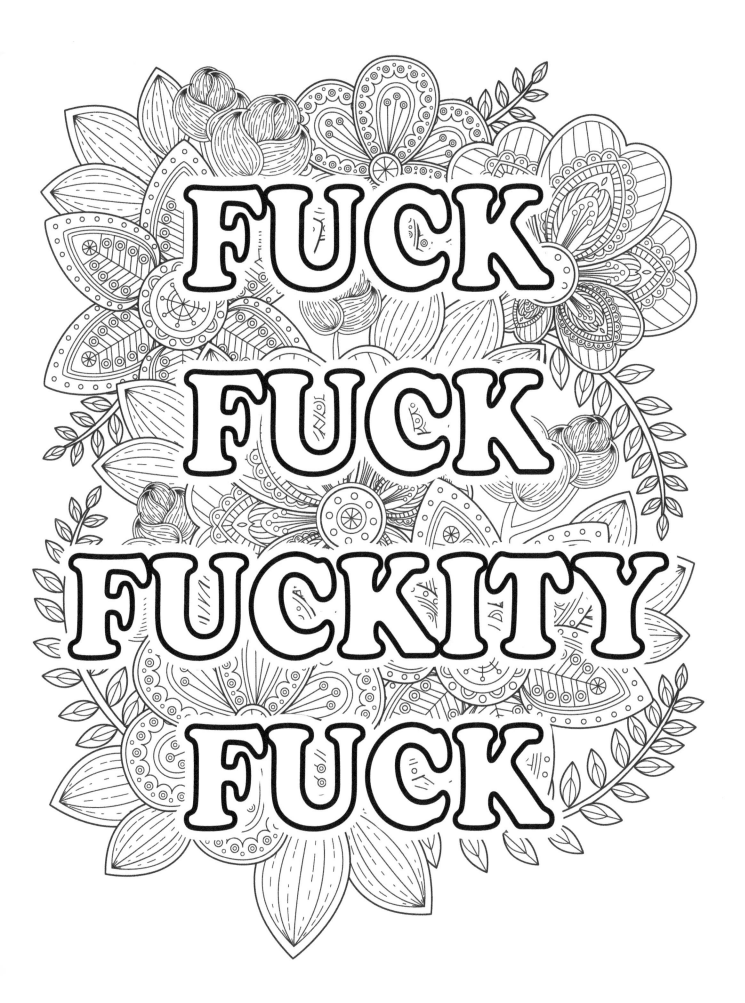

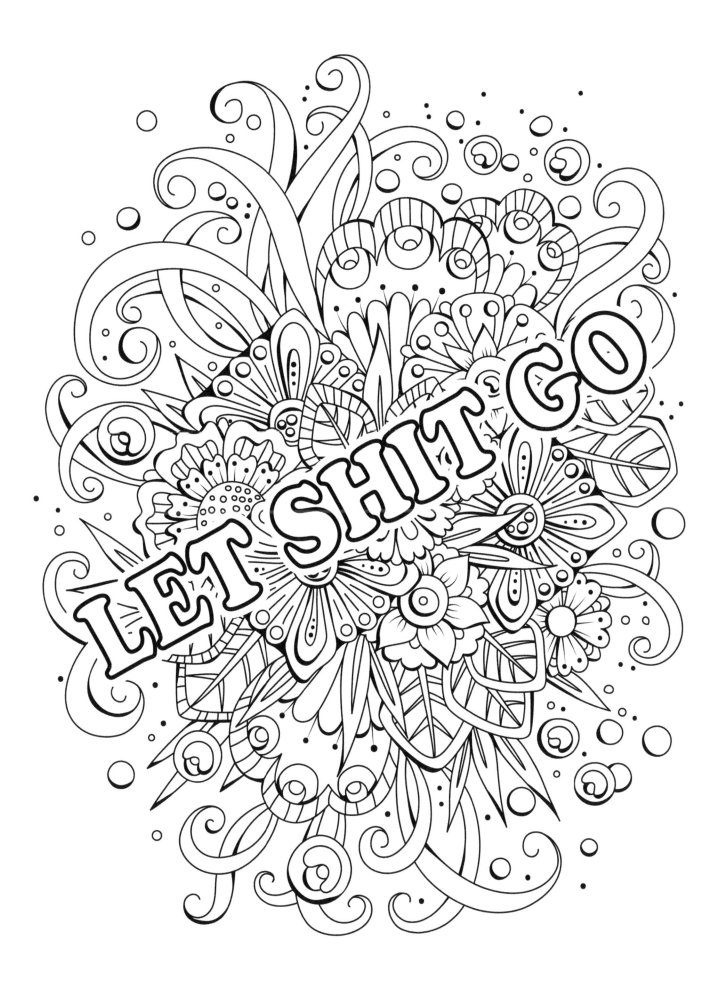

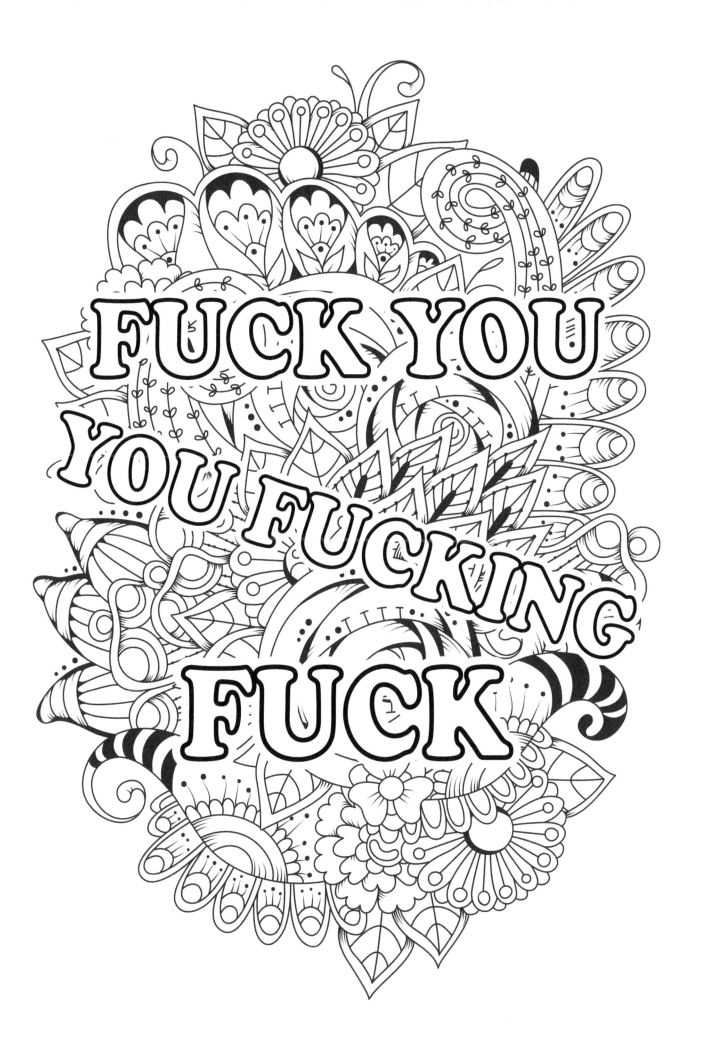

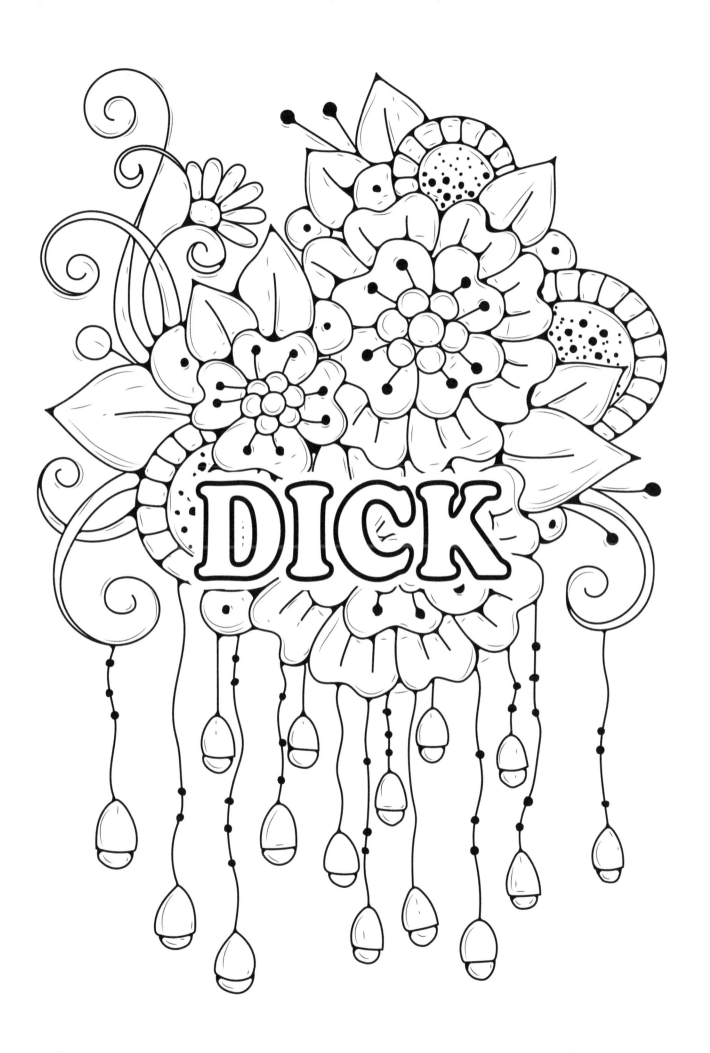

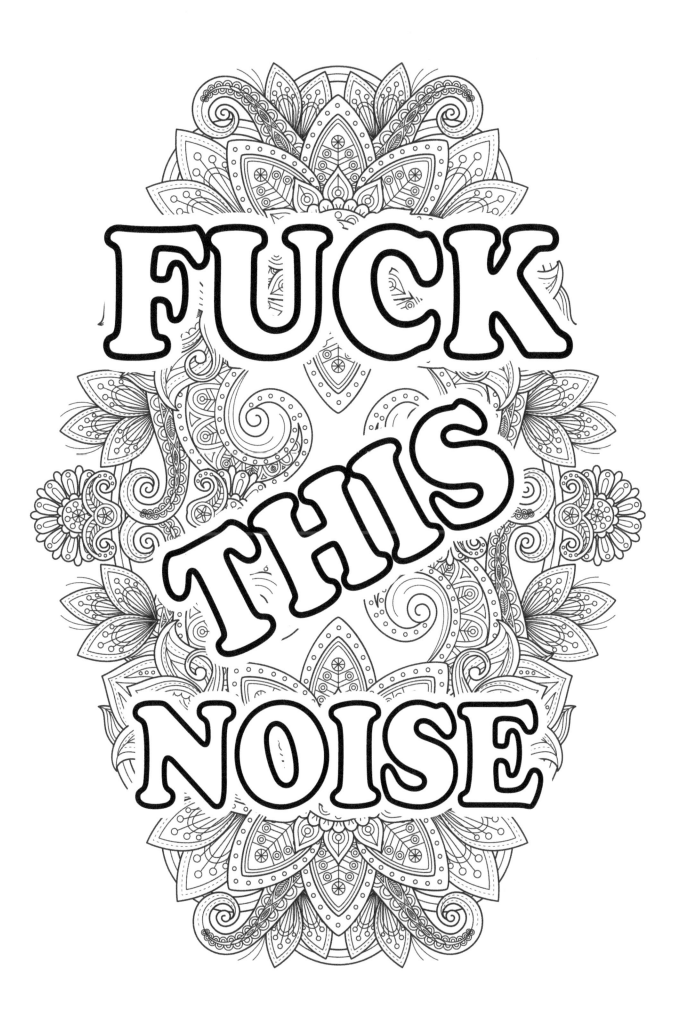

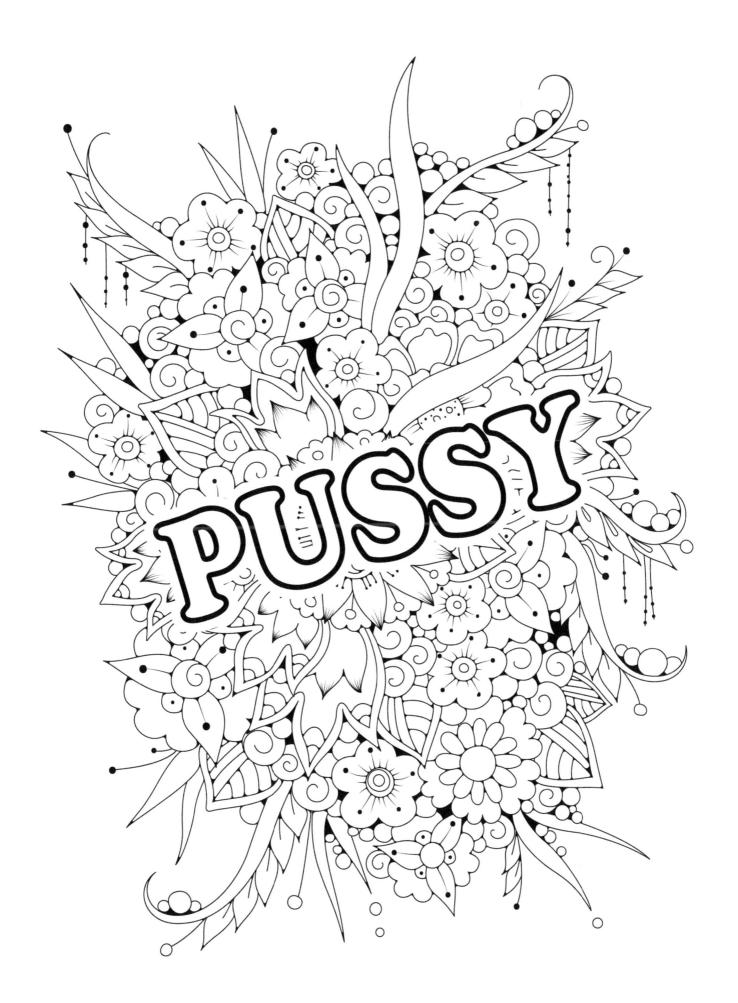

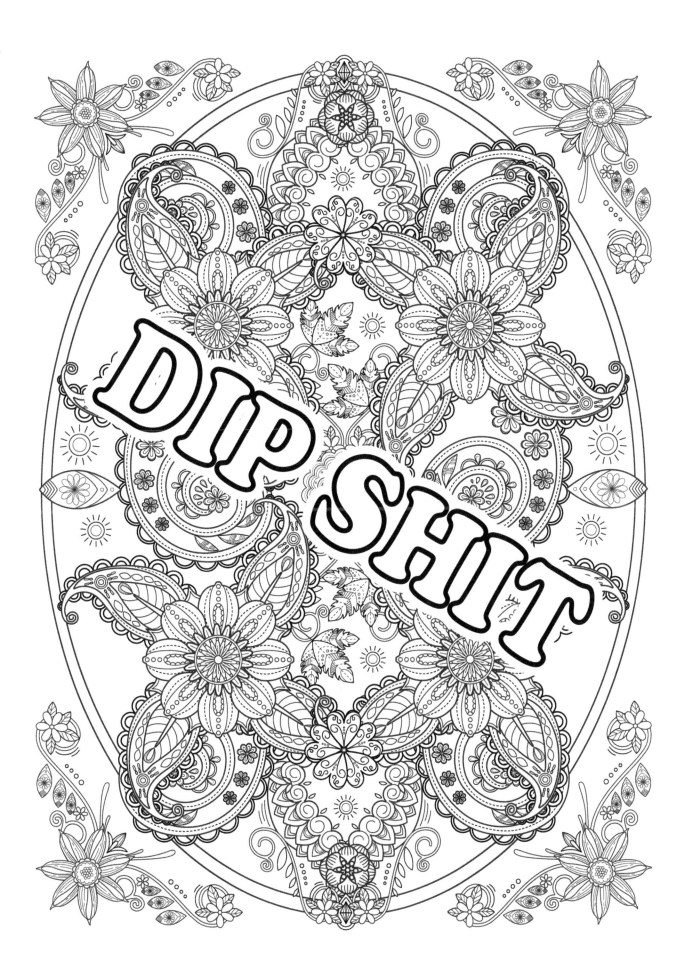

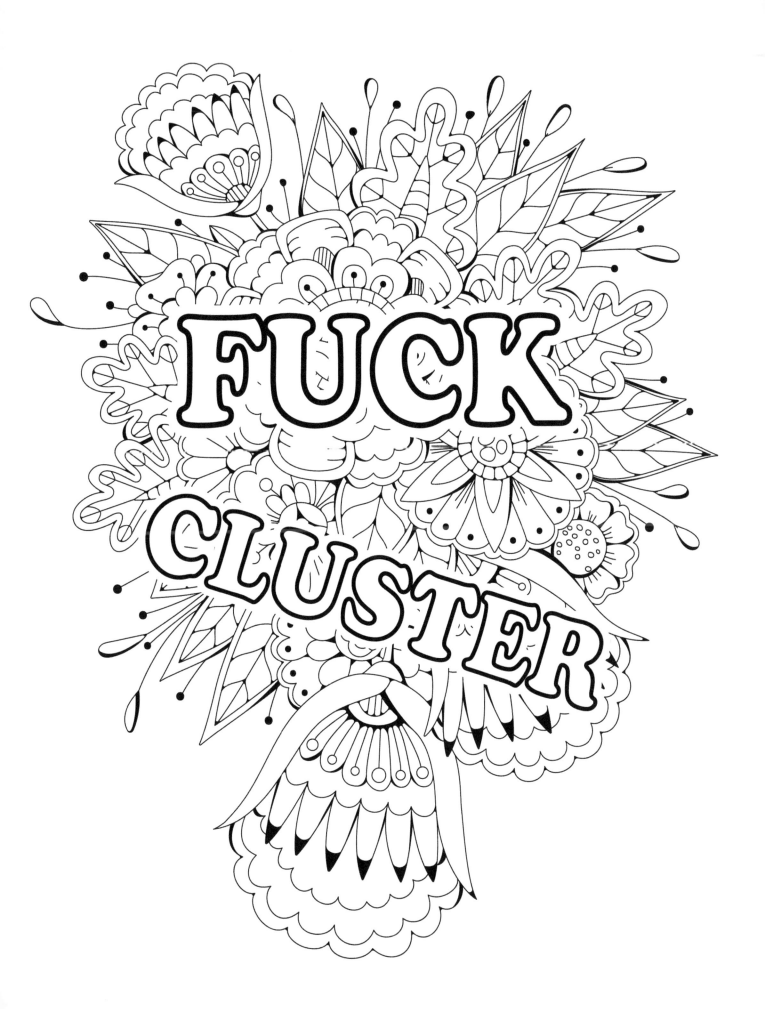

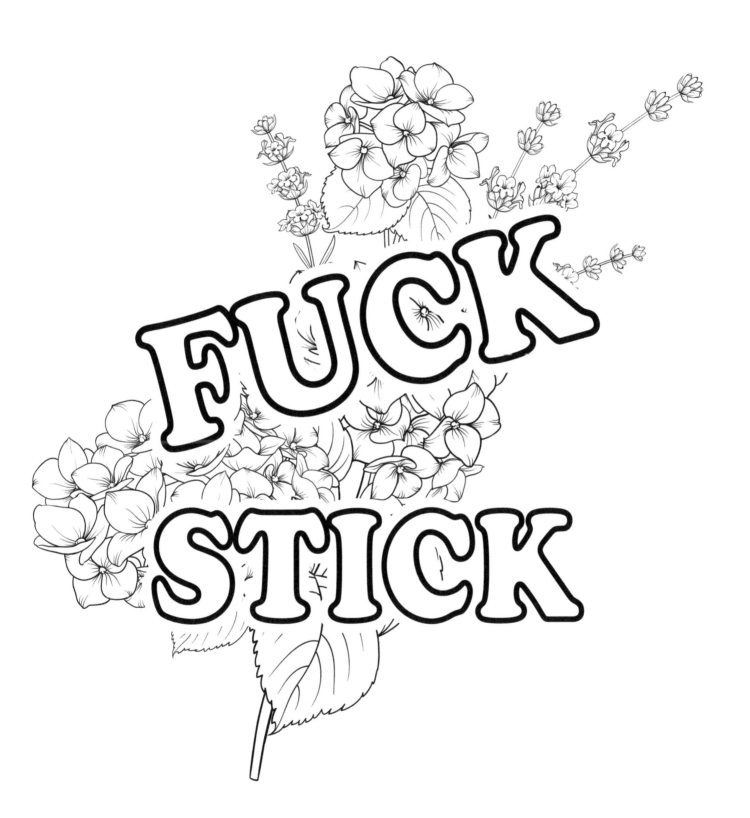

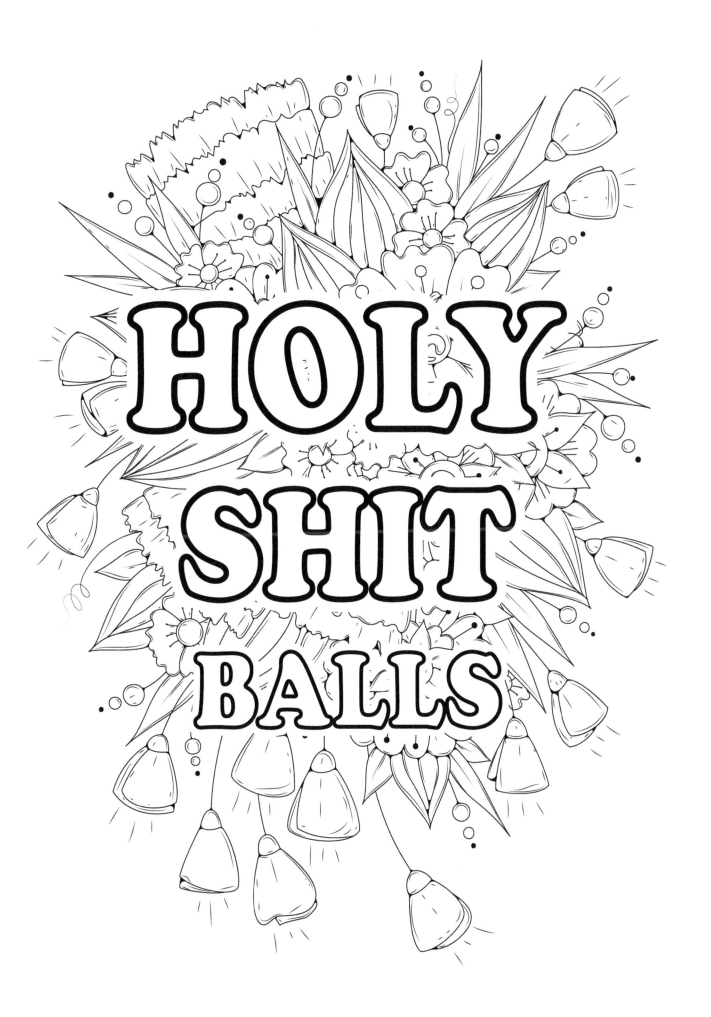

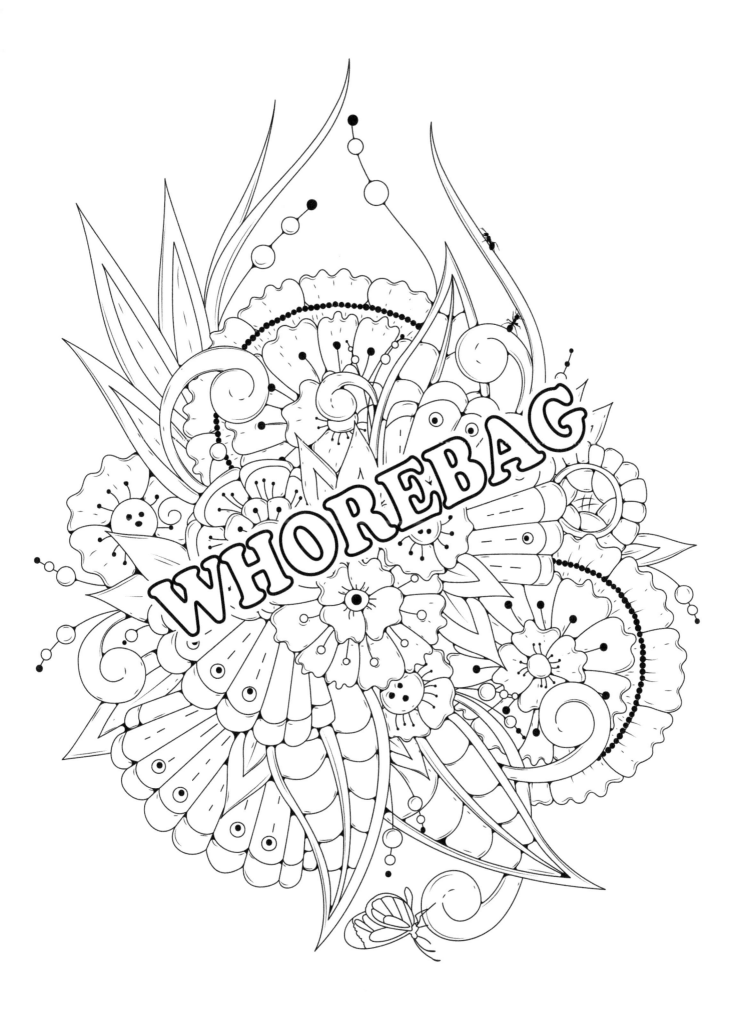

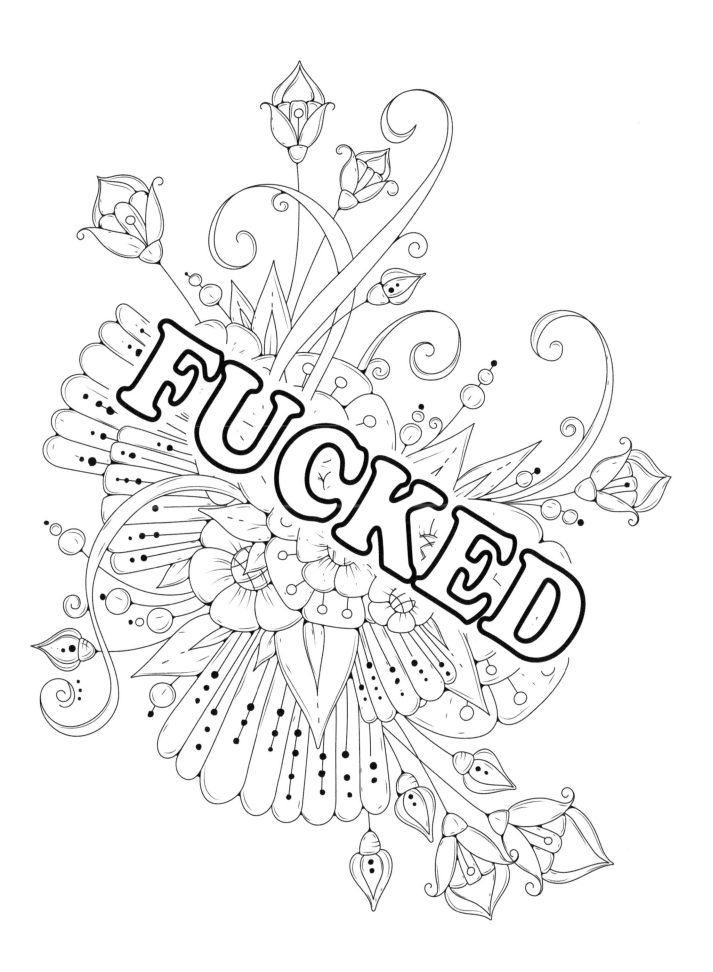

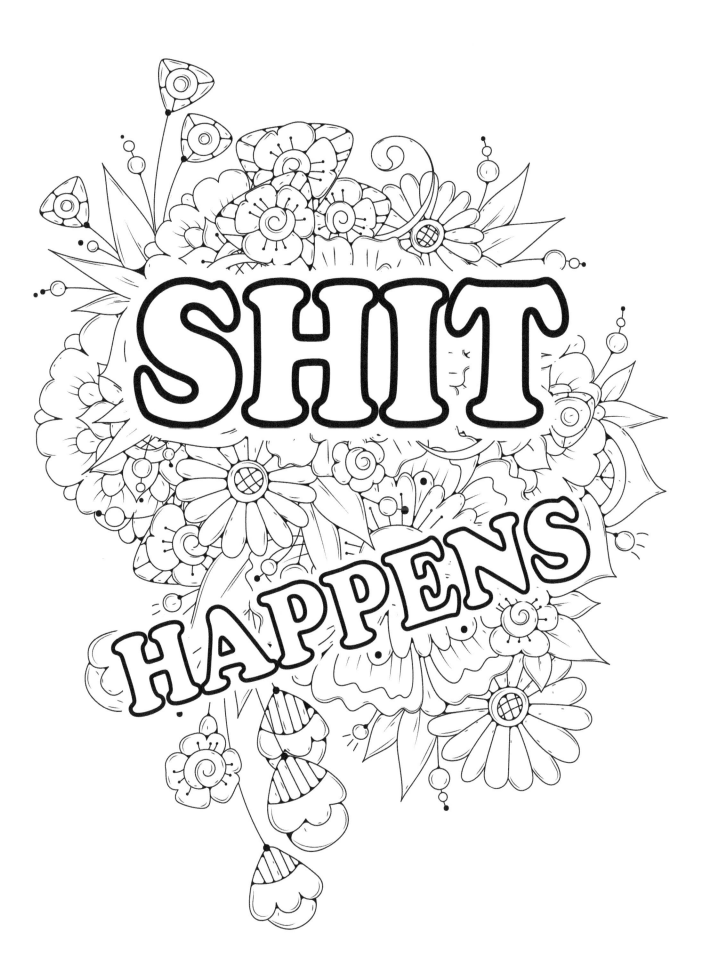

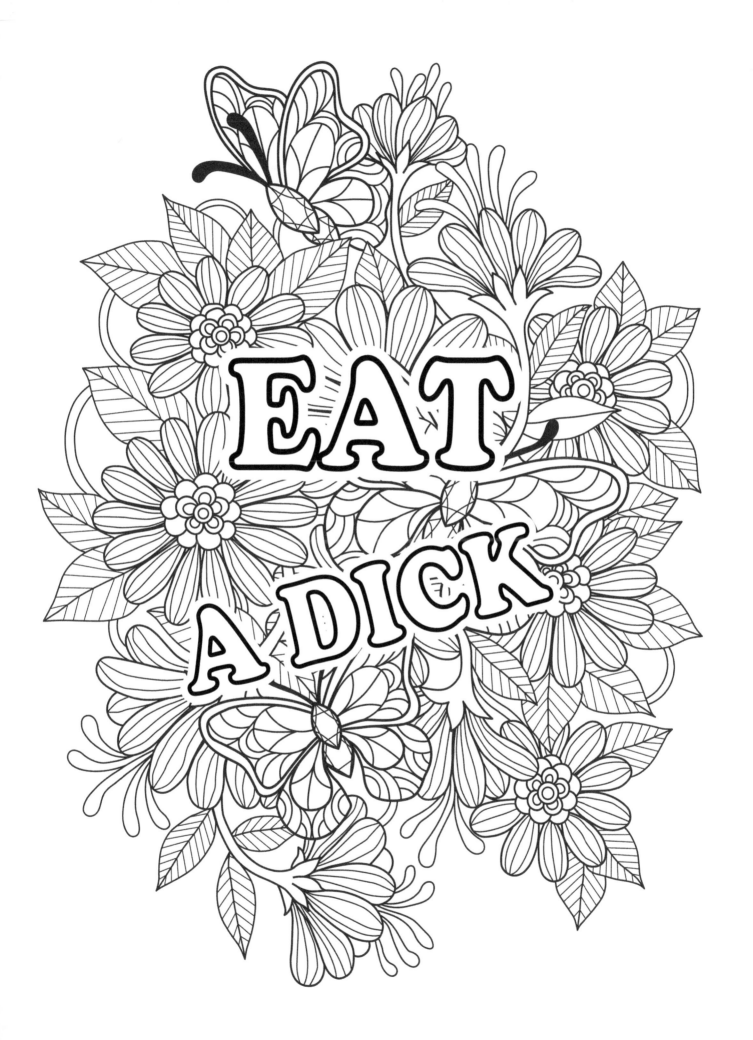

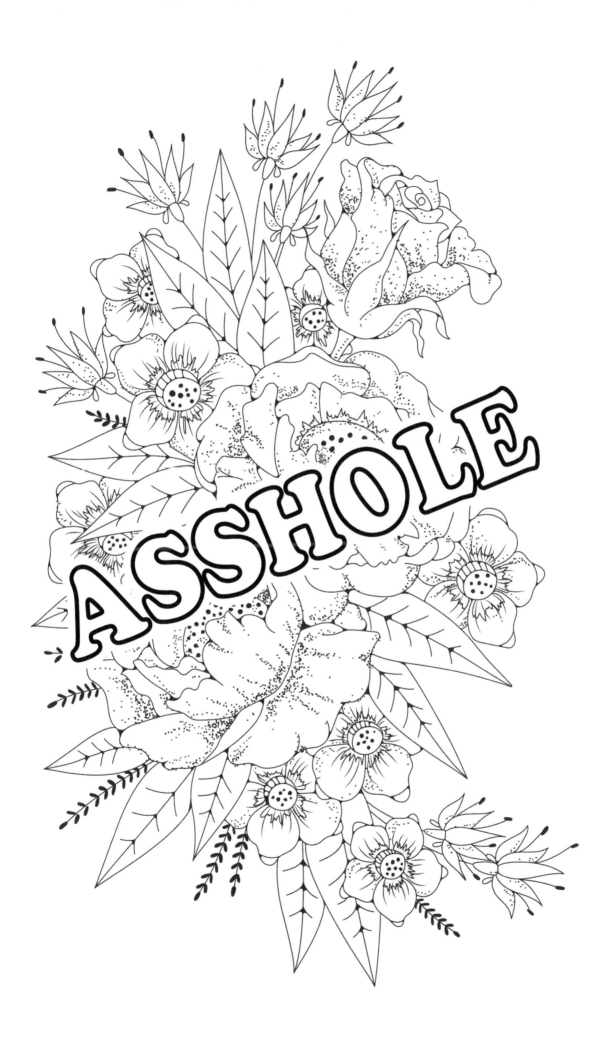

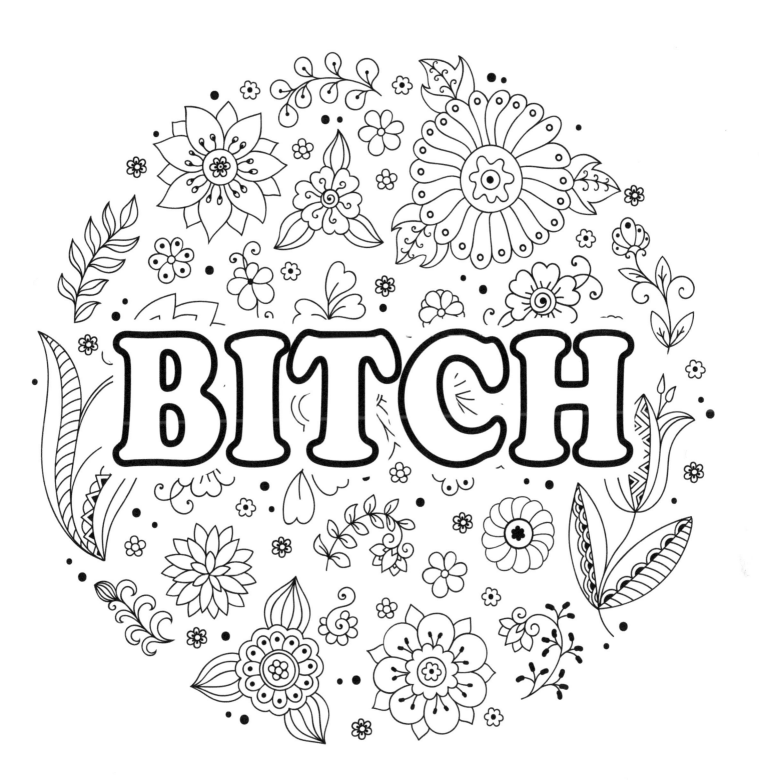

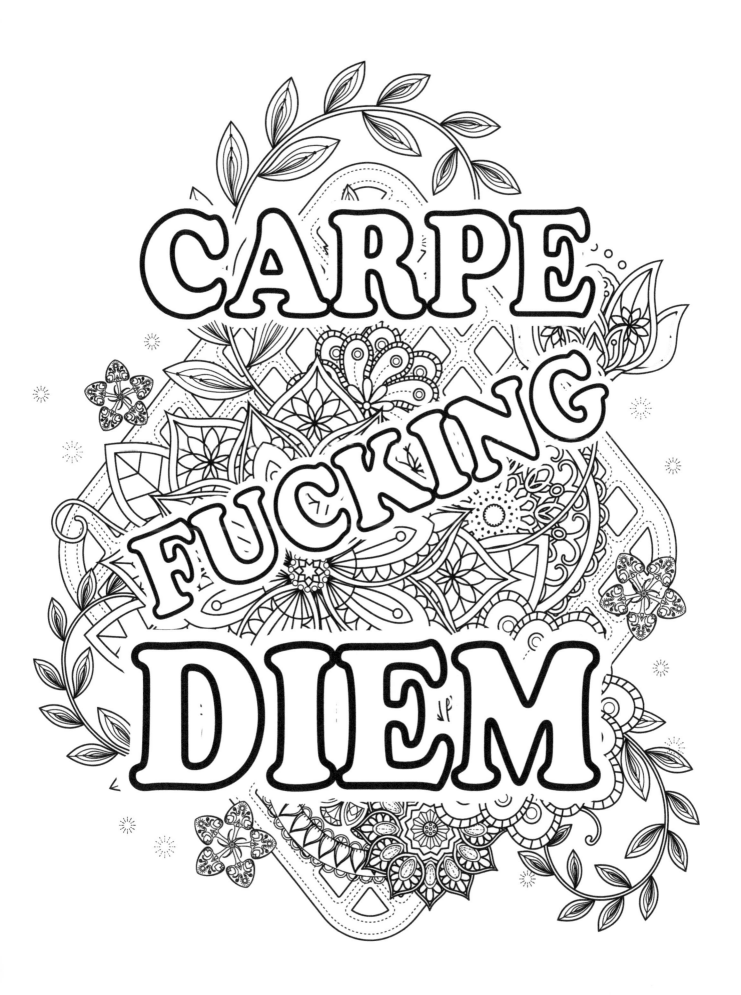

Printed in the USA
CPSIA information can be obtained
at www.ICGtesting.com
LVHW061222011224
798050LV00039B/2136